Nirvana

Coloring for Artists

Skyhorse Publishing

Copyright © 2016 by Skyhorse Publishing, Inc.

Artwork copyright © 2016:

Shutterstock/Netfalls - Remy Musser (Intro image: Ganesha)

Shutterstock/edography (Intro image: Durga statue)

Shutterstock/Tewan Banditrukkanka (Intro image: lotus)

Shutterstock/Ajay Shrivastava (Image 1)

Shutterstock/Mahesh Patil (Image 2)

Shutterstock/Shumo4ka (Image 3, 4)

Shutterstock/Vectomart (Image 5)

Shutterstock/OkPic (Image 6, 11)

Shutterstock/sunlight77 (Image 7, 28)

Shutterstock/Annareichel (Image 8)

Shutterstock/RoseGarden (Image 9)

Shutterstock/kiya-nochka (Image 10, 15, 19)

Shutterstock/FCks (Image 12, 27)

Shutterstock/GreenTree (Image 13)

Shutterstock/Mrs. Opossum (Image 14)

Shutterstock/moopsi (Image 16)

Shutterstock/Tisha Ardis (Image 17, 18)

Shutterstock/grafnata (Image 20)

Shutterstock/Andrei Verner (Image 21)

Shutterstock/omtatsat graphic (Image 22)

Shutterstock/Watercolor-swallow (Image 23)

Shutterstock/Somkiat19 (Image 24)

Shutterstock/codesyn (Image 25)

Shutterstock/karakotsya (Image 26, 31, 35)

Shutterstock/Bigio (Image 29)

Shutterstock/Transia Design (Image 30)

Shutterstock/Fargon (Image 32)

Shutterstock/mr_owlman (Image 33)

Shutterstock/Gorbash Varvara (Image 34, 39, 40)

Shutterstock/Ekaterina Gerasimova (Image 36, 37, 38, 43)

Shutterstock/An Vino (Image 41)

Shutterstock/Nancy White (Image 42)

Shutterstock/panki (Image 44)

Shutterstock/Nikolayenko Yekaterina (Image 45)

Shutterstock/Katyau (Image 46)

Skyhorse Publishing books may be purchased in bulk at special discounts for sales promotion, corporate gifts, fund-raising, or educational purposes. Special editions can also be created to specifications. For details, contact the Special Sales Department, Skyhorse Publishing, 307 West 36th Street, 11th Floor, New York, NY 10018 or info@skyhorsepublishing.com.

Skyhorse® and Skyhorse Publishing® are registered trademarks of Skyhorse Publishing, Inc.®, a Delaware corporation.

Visit our website at www.skyhorsepublishing.com.

10 9 8 7 6 5 4 3 2

Library of Congress Cataloging-in-Publication Data is available on file.

Cover design by Jane Sheppard
Cover artwork credit: Shutterstock/sunlight77
Text by Chamois S. Holschuh

Print ISBN: 978-1-5107-0953-9

Printed in the United States of America.

Nirvana:
Coloring for Artists

Nirvana, a term utilized in several religions including Buddhism, Hinduism, Jainism, and Sikhism, is the profound state of mind wherein a person reaches an ultimate peace. To achieve nirvana, one must become enlightened to the point where ego disappears. There can be no sense of desire, anger, or ambition: only an awareness of the self and an ultimate understanding that the universe exists beyond our selves. To aspire toward nirvana is a serious undertaking that must be approached with great humility and patience. Meditation-promoting cultures often teach about nirvana, whether they use that term or another for the concept.

This coloring book was inspired by the noble teachings and well known icons of such cultures. You'll find a selection of hamsas, mandalas, om symbols, and various deities, including Ganesha, Vishnu, Shiva, Durga, and Buddha. In fact, let's take a moment to revisit some of the important attributes of these individuals and emblems. (Please note that these descriptions are by no means comprehensive but at least provide an introduction to these important icons.) Often depicted with a third eye, a snake around his neck, and a crescent moon adornment, along with other symbols, Shiva is one of the better known Hindu gods. He is considered the patron god of yoga and the arts as well as "the Destroyer." One of his children, Ganesha, is even more widely recognized given his unique elephant head, and worship of him extends beyond Hinduism to include other religions such as Buddhism. Ganesha is the patron god of art (like his father), science, intellect, wisdom, letters, and learning. A mouse is often included in depictions

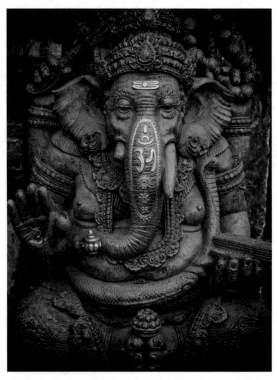

Ganesha is considered the "Remover of Obstacles" as well as the patron saint of wisdom and learning.

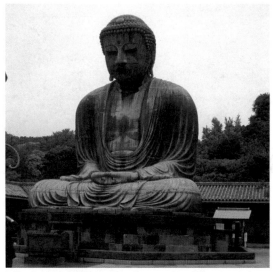

The Great Buddha at Kōtoku-in, a Buddhist temple in Kamakura, Japan (c. 1252 CE).

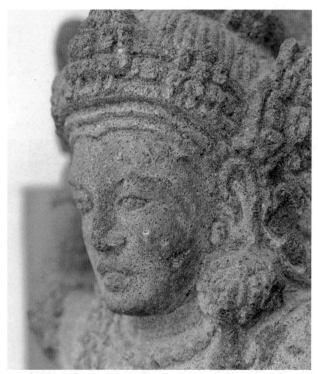

Tenth century statue of the goddess Durga; she is regarded as the root cause of creation, preservation, and annihilation.

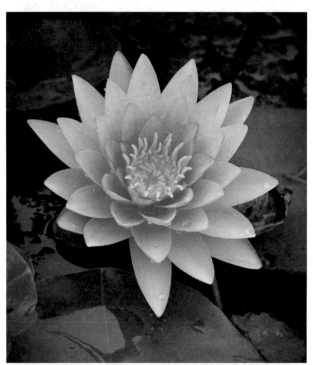

Rooted in mud yet floating on clear water, the beauty of the lotus flower represents transcendence from imperfection to purity.

of Ganesha, with the undesirable rodent appearing near if not under his feet. This positioning is believed to represent Ganesha's dominance over things that should be overcome; this corresponds to his role as "Remover of Obstacles." Vishnu, often blue-colored, is "the Preserver" or "the Protector." With his four hands, he holds a sacred lotus flower, a mace, a conch shell, and a discus—all important symbols of enlightenment and power. The sacred lotus flower, or padma, is an important symbol in both Hinduism and Buddhism. Its many petals signify a gradual opening of the soul. Rooted in mud yet floating on the surface of water, the flower also represents transcendence above attachment and desire, culminating in the purity of body, speech, and mind. Pervasive in Hindu and Buddhist iconography, the lotus has even inspired a famous yoga pose which you'll also recognize as the usual posture of Buddha as given in statues, paintings, drawings, and so on. Furthermore, legend has it that everywhere the child Buddha walked, lotus flowers blossomed.

We hope you'll use this coloring book as a creative tool for meditation and reflection. The designs have all been selected for their unique representations of philosophical emblems, requiring only your imagination to bring them to their full splendor. In the next few pages, you'll find pre-colored versions of the black-and-white designs. These are meant to provide guidance if you wish or simply to inspire your own visions. The pages are perforated, so you may remove them for a more comfortable coloring experience. When you are finished, place them on display for daily revisitation. Gather your thoughts and favorite art medium, relax, and meditate while you color.

1

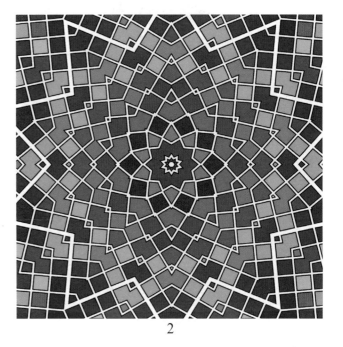

2

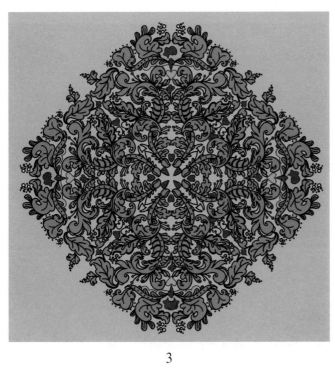

3

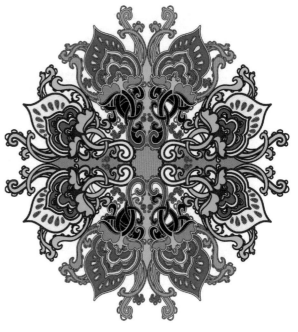

4

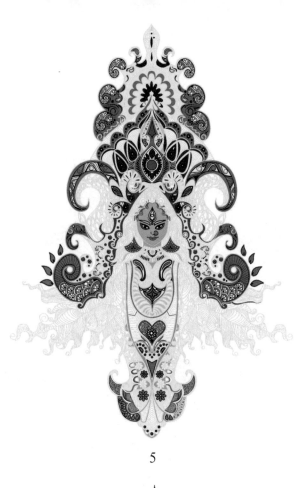

5

6

7

8

9

10

11

12

13

14

15

16

17

18

19

20

21

22

23

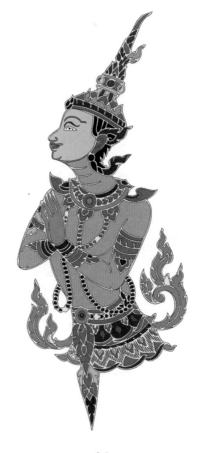

24

25

26

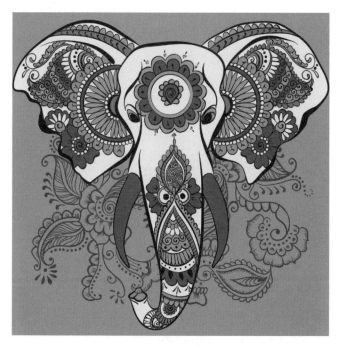

27

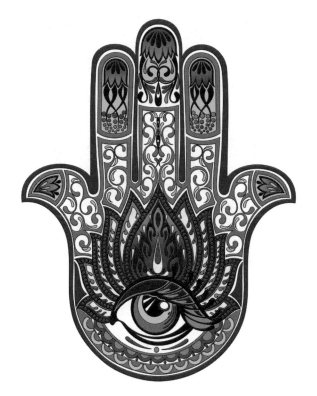

28

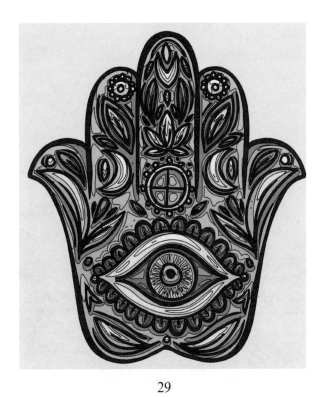

29

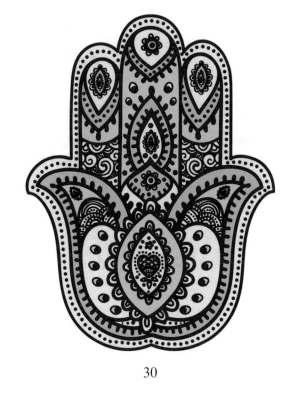

30

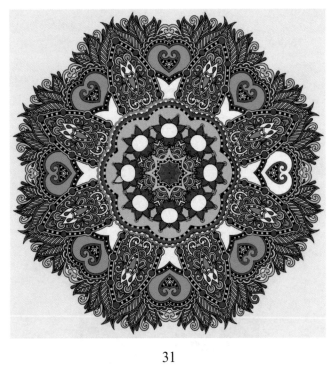

31

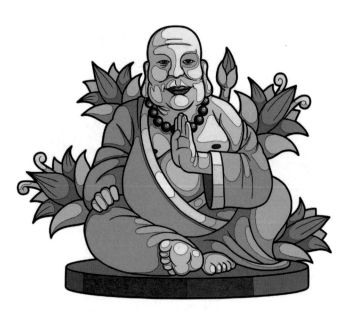

32

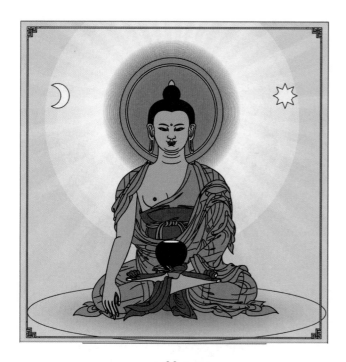

33

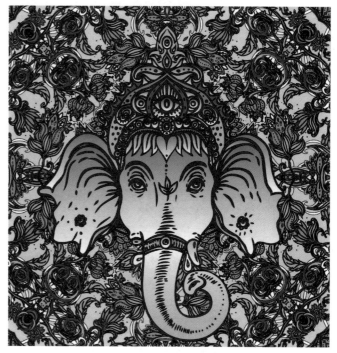

34

35

36

37

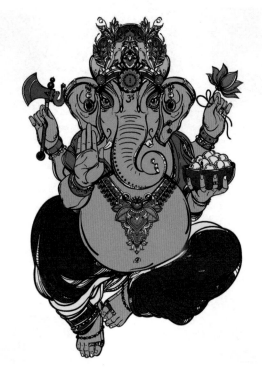

38

39

40

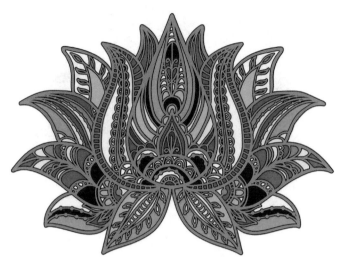

42

41

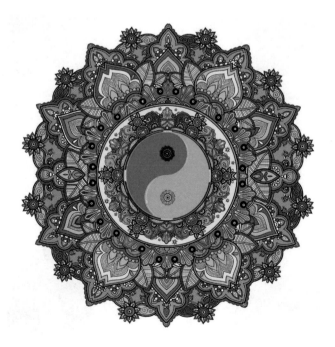

43

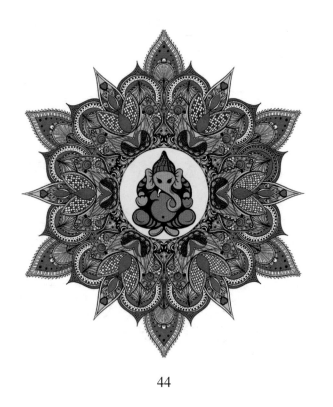

44

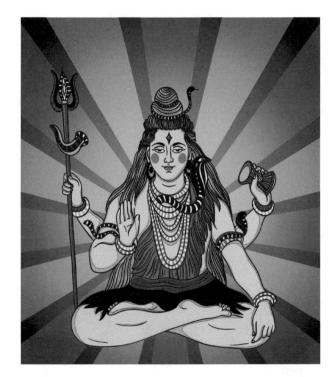

45

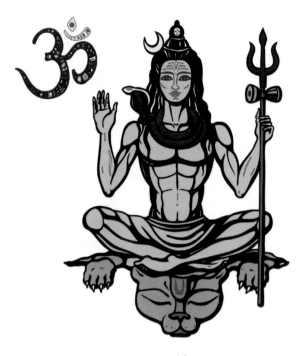

46

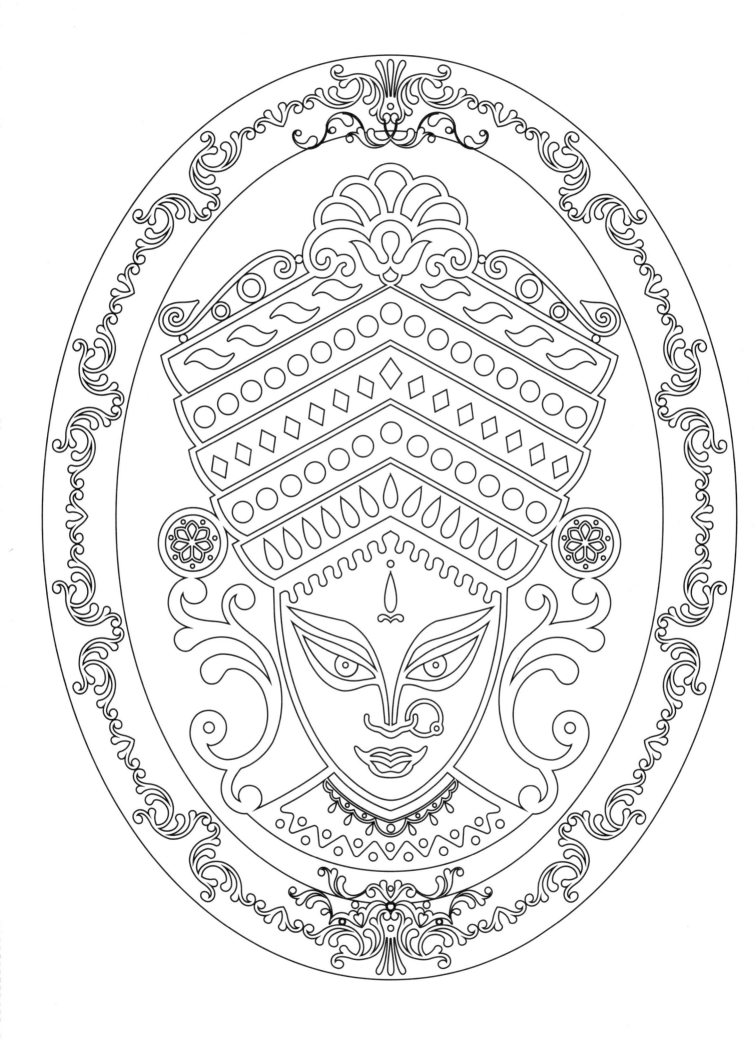

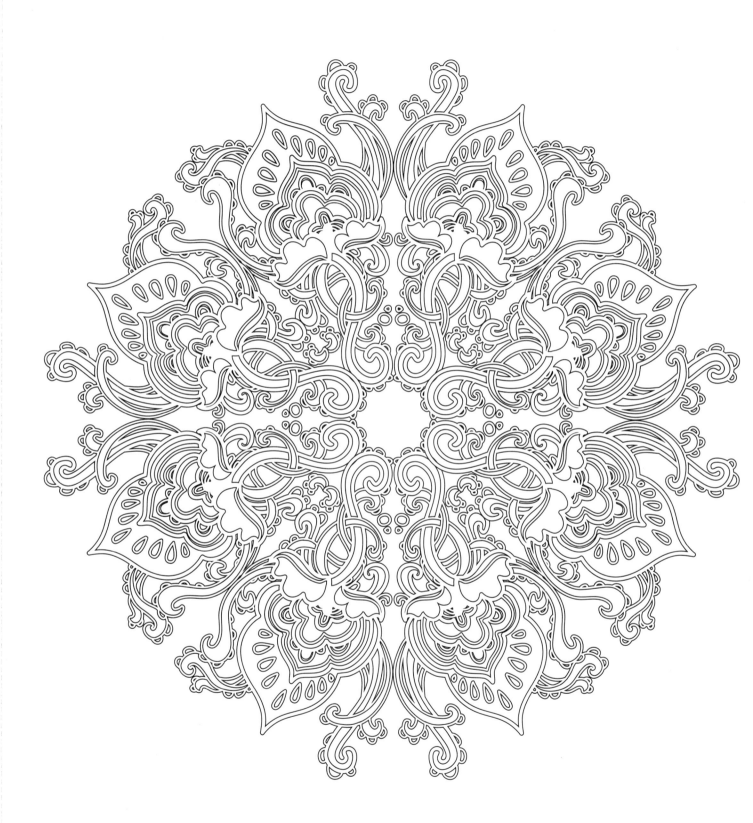

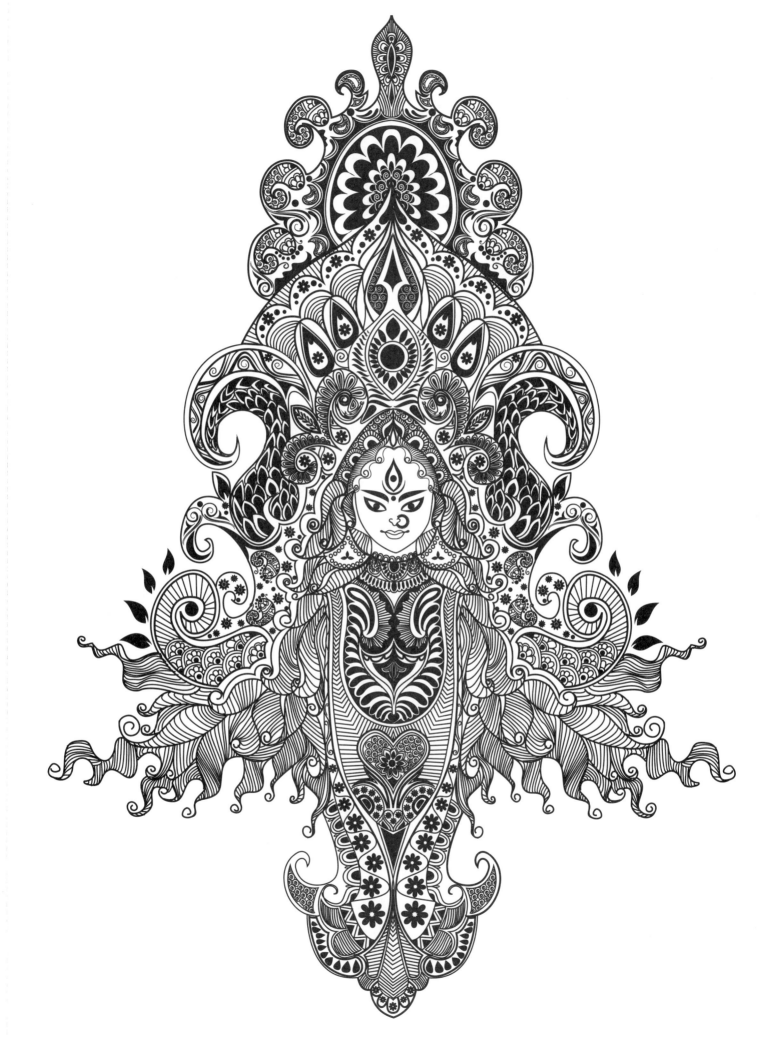

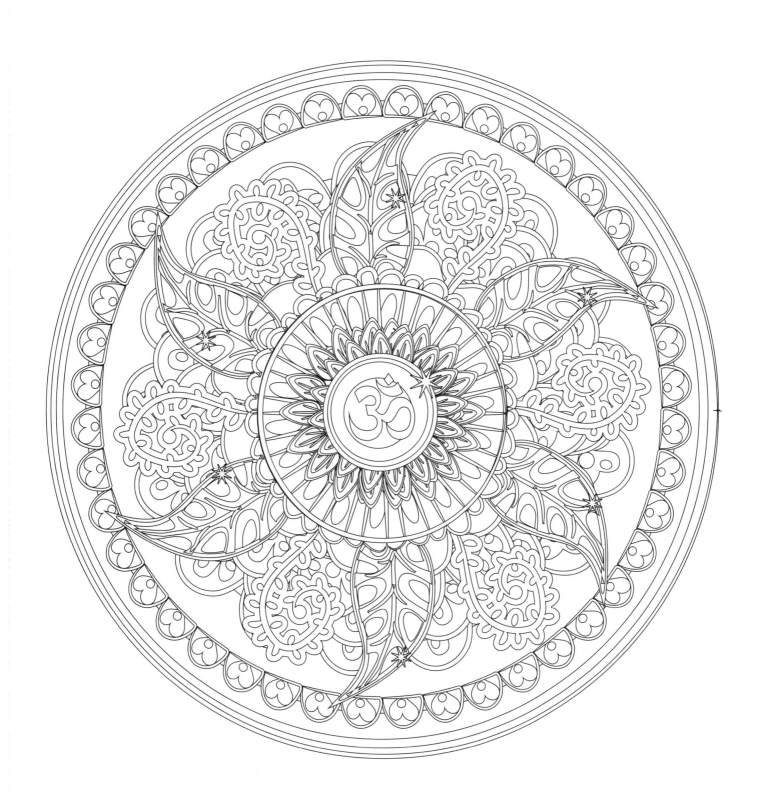

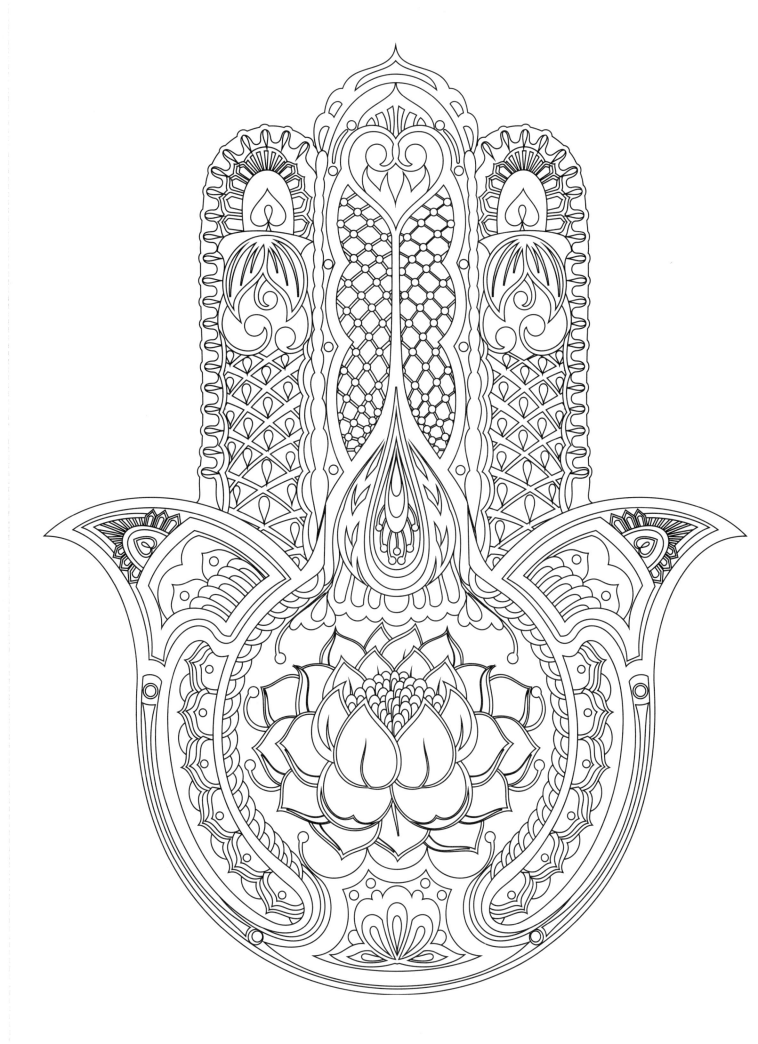

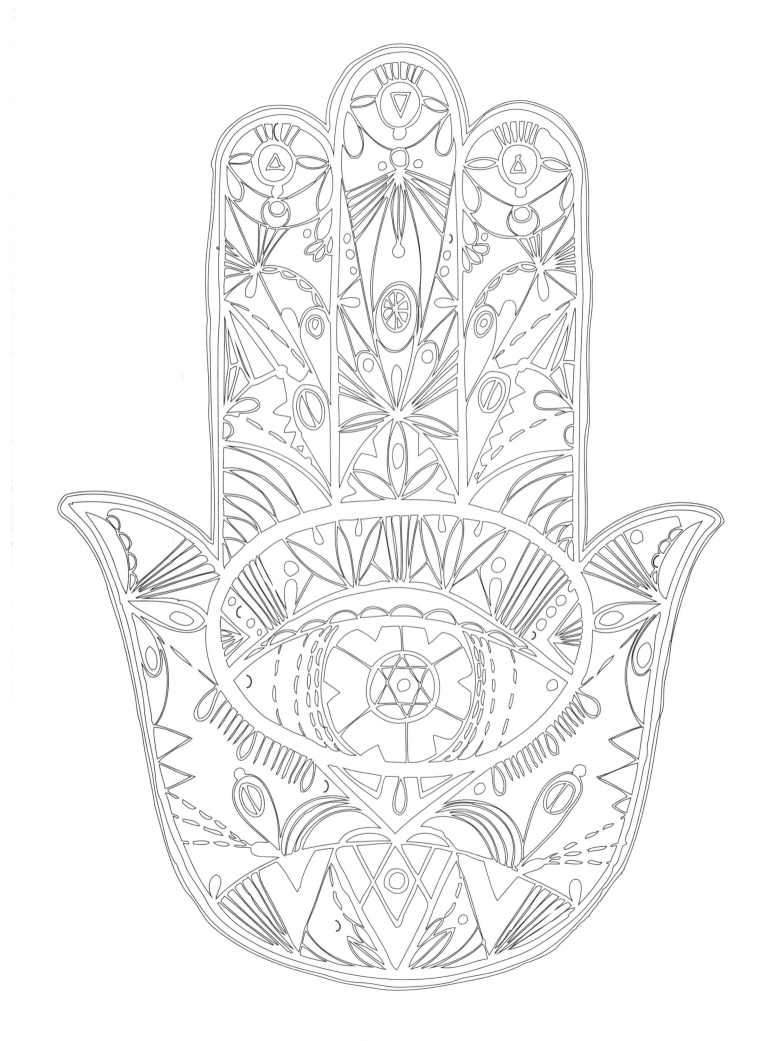

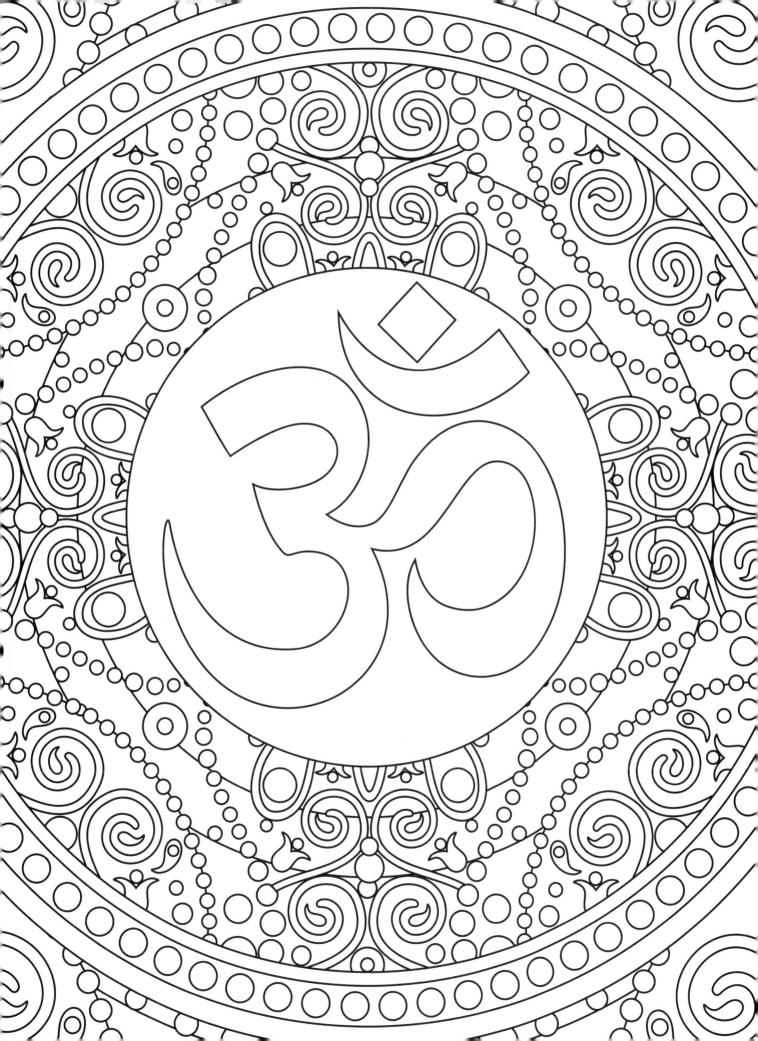

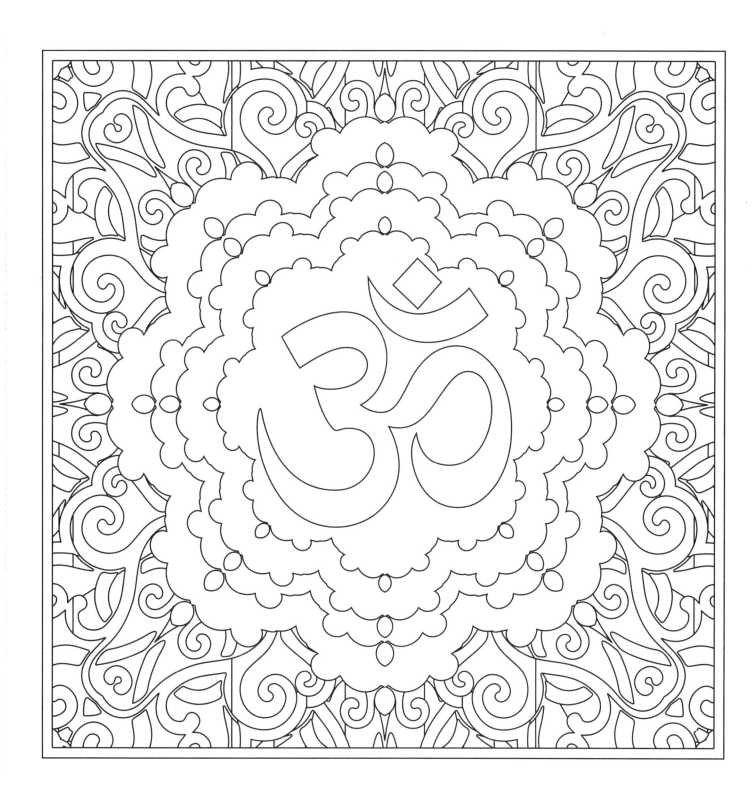

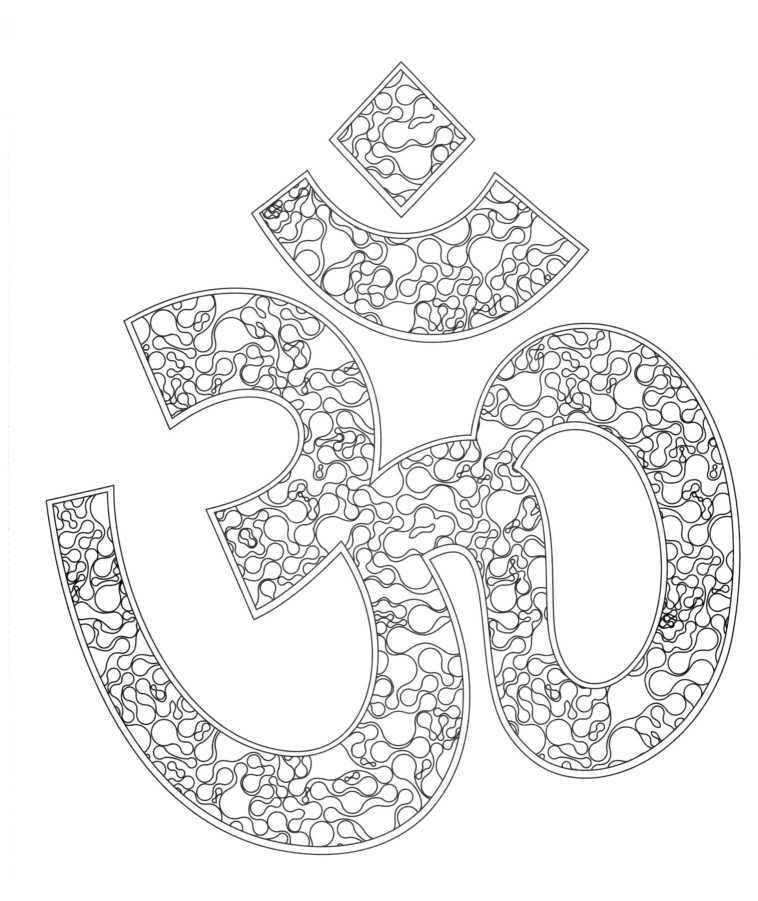

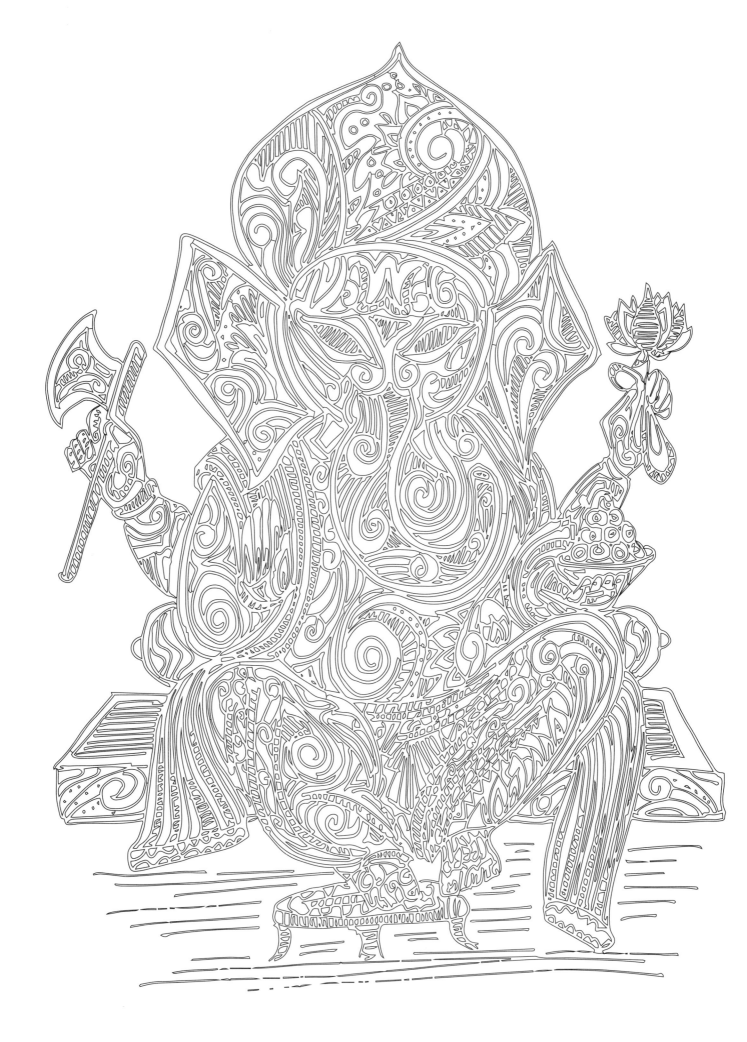

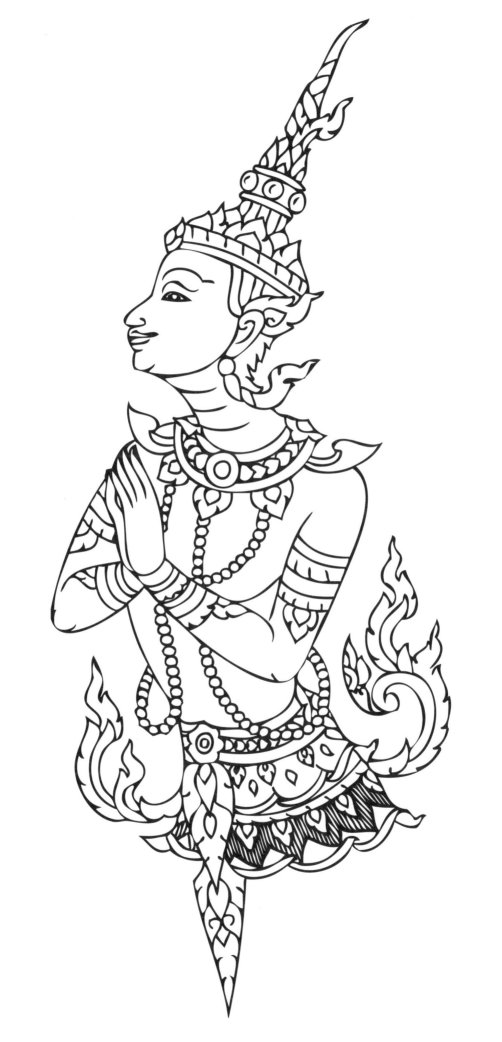

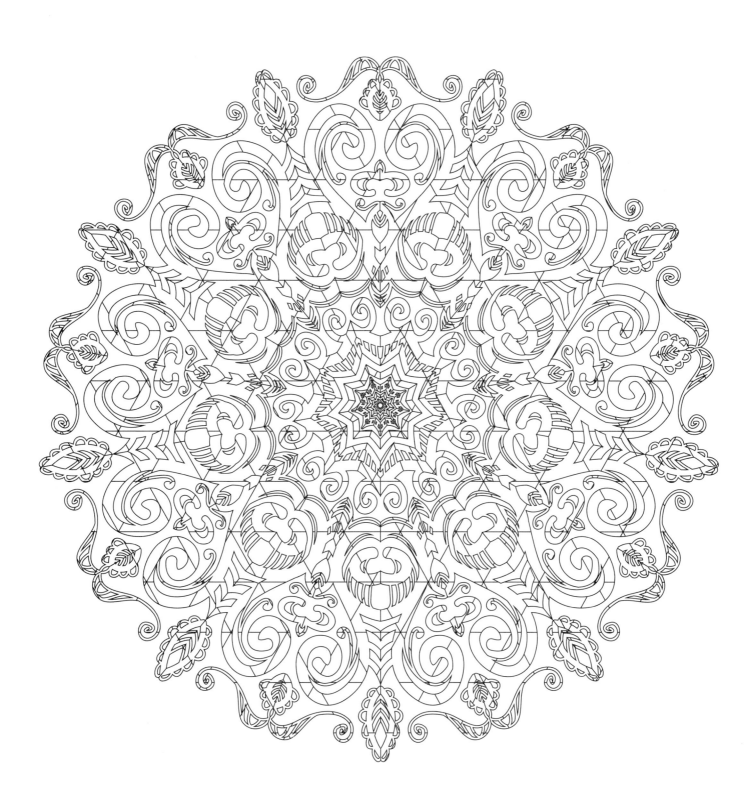

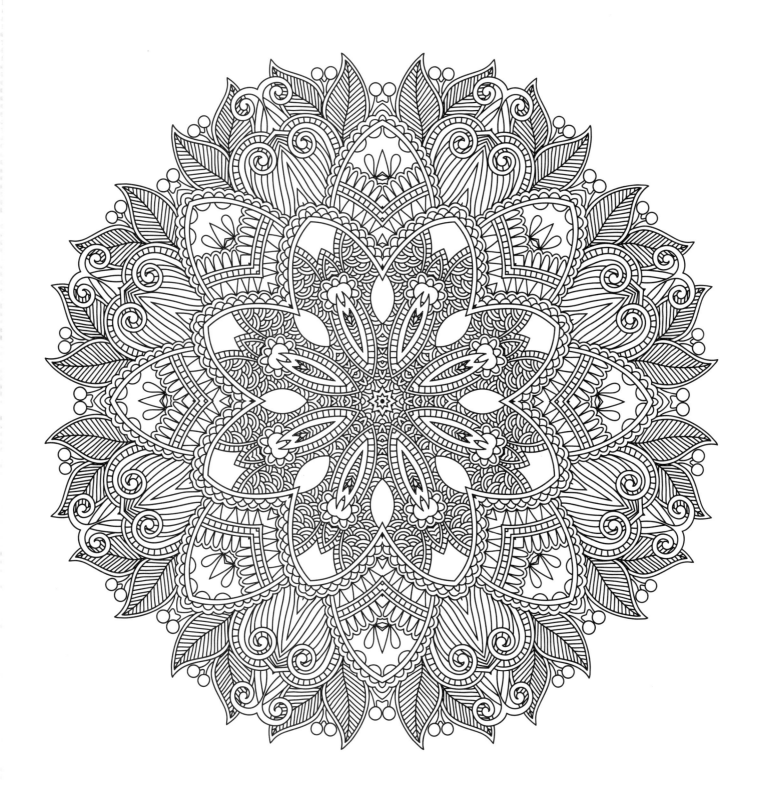

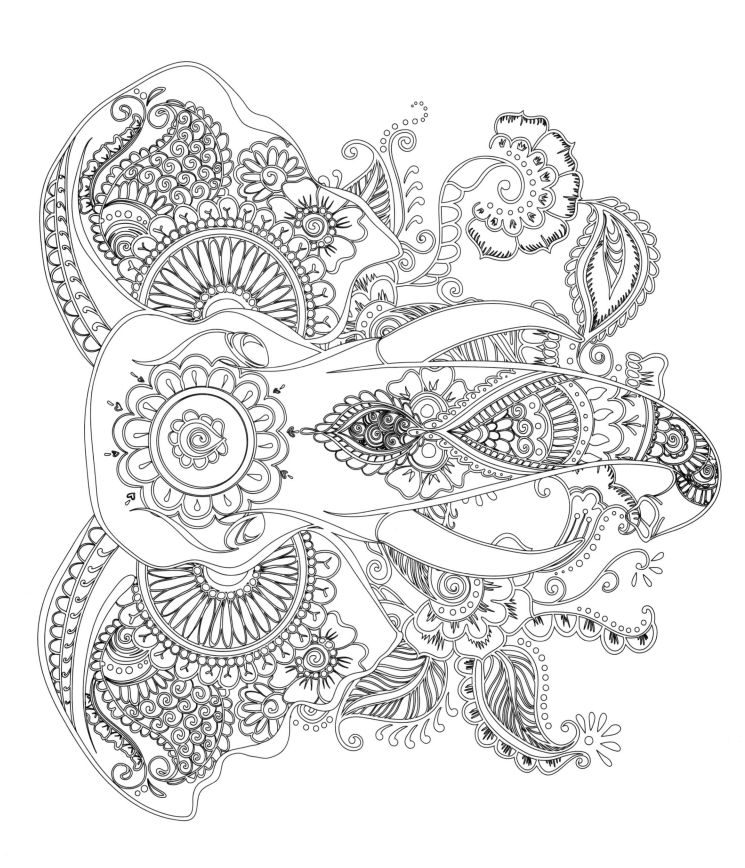

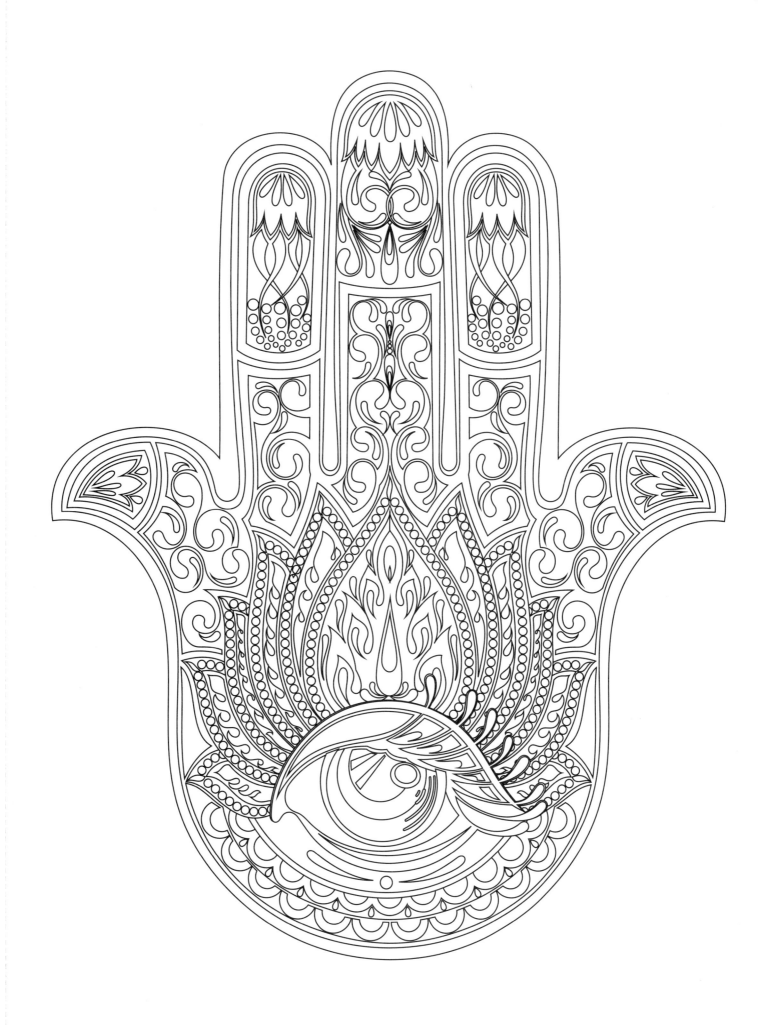

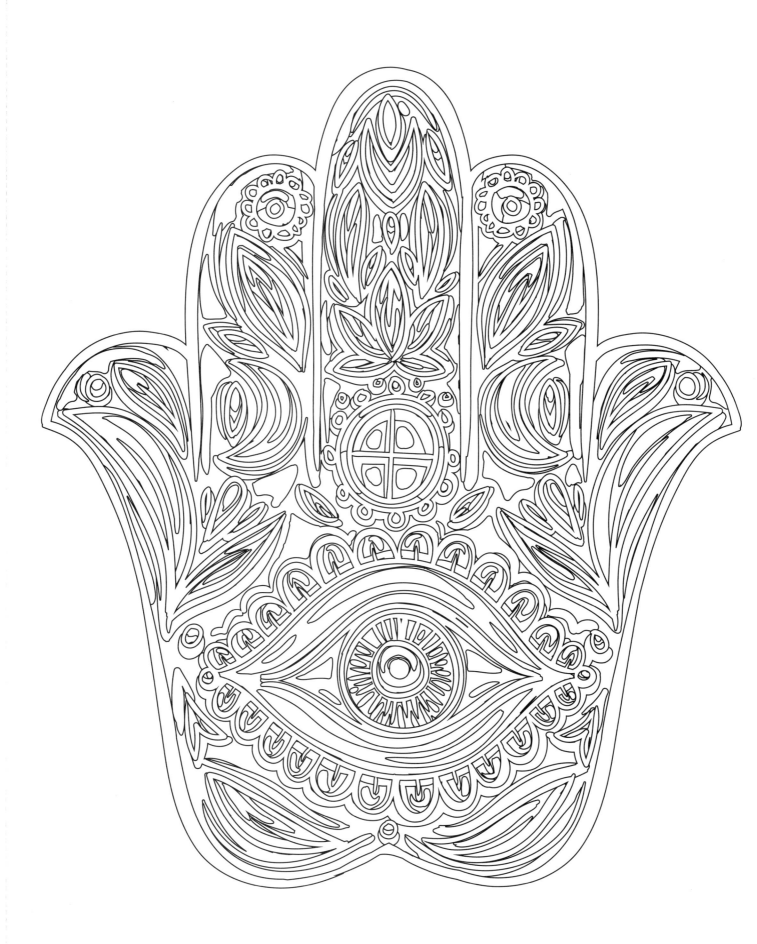

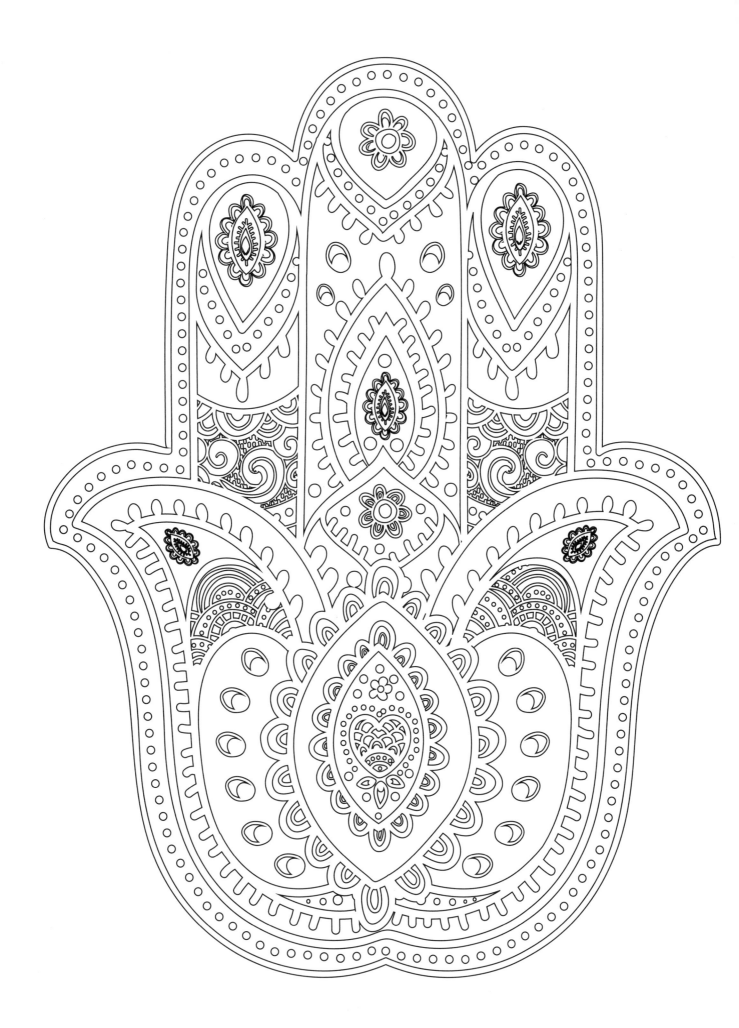

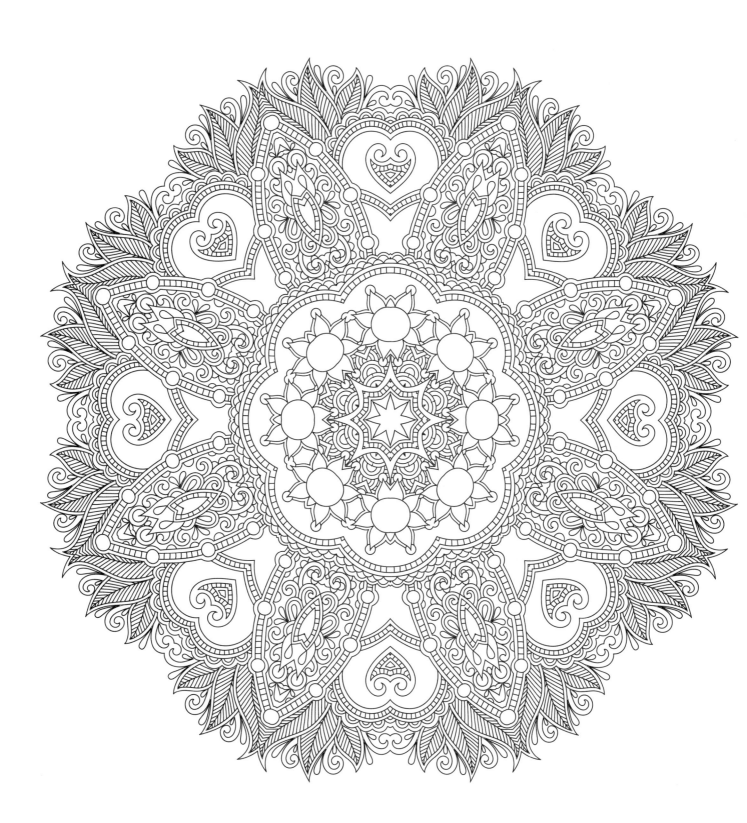

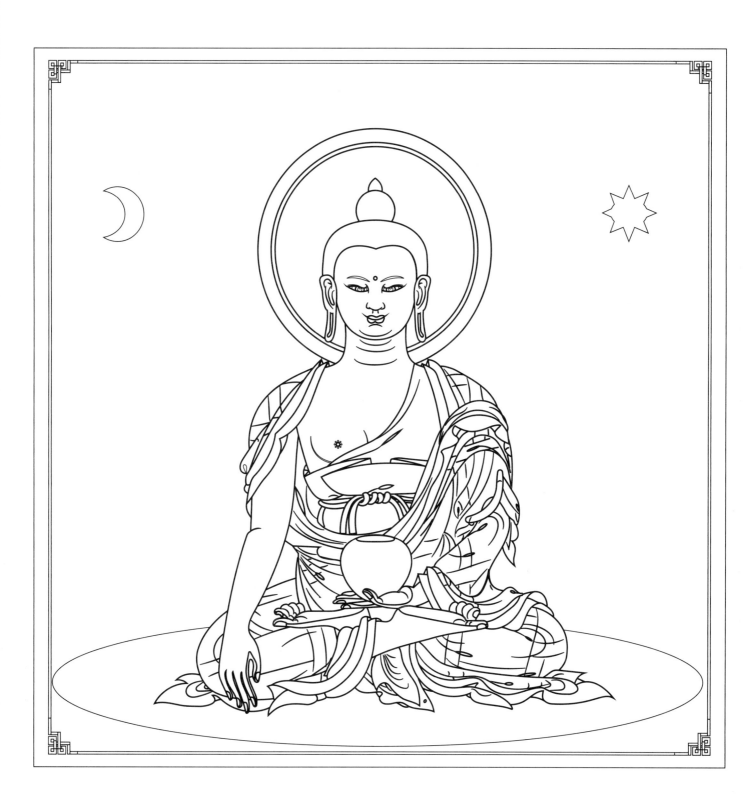

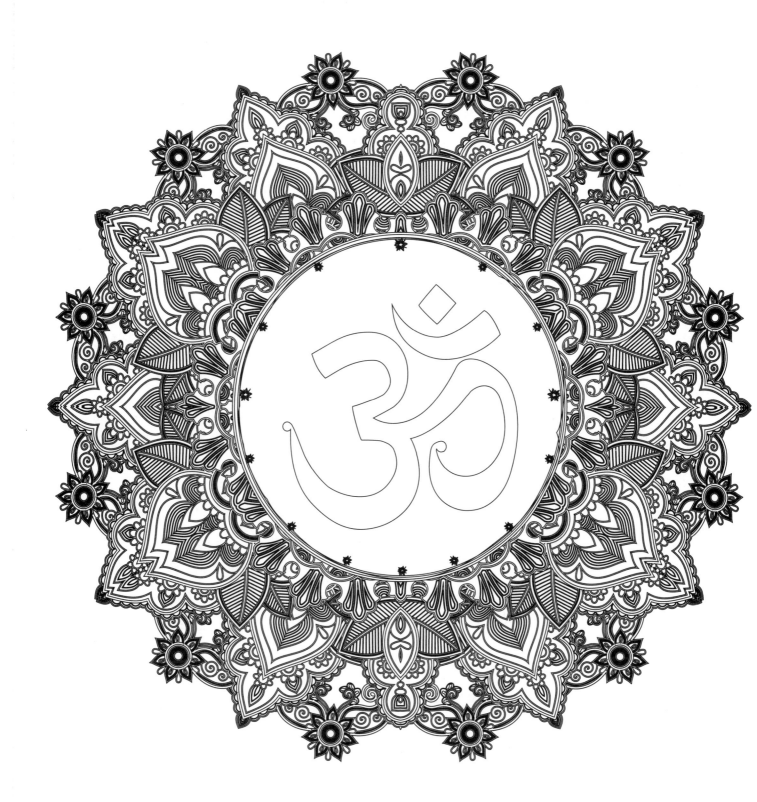

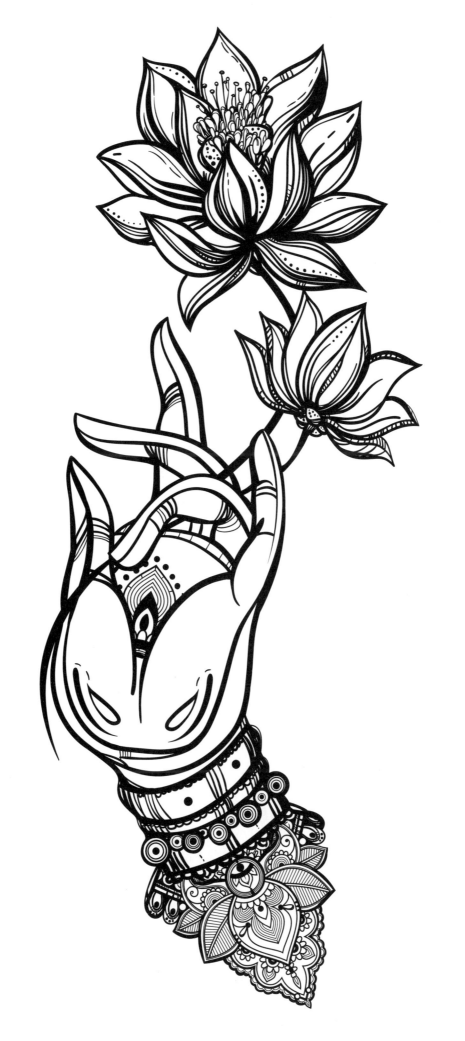

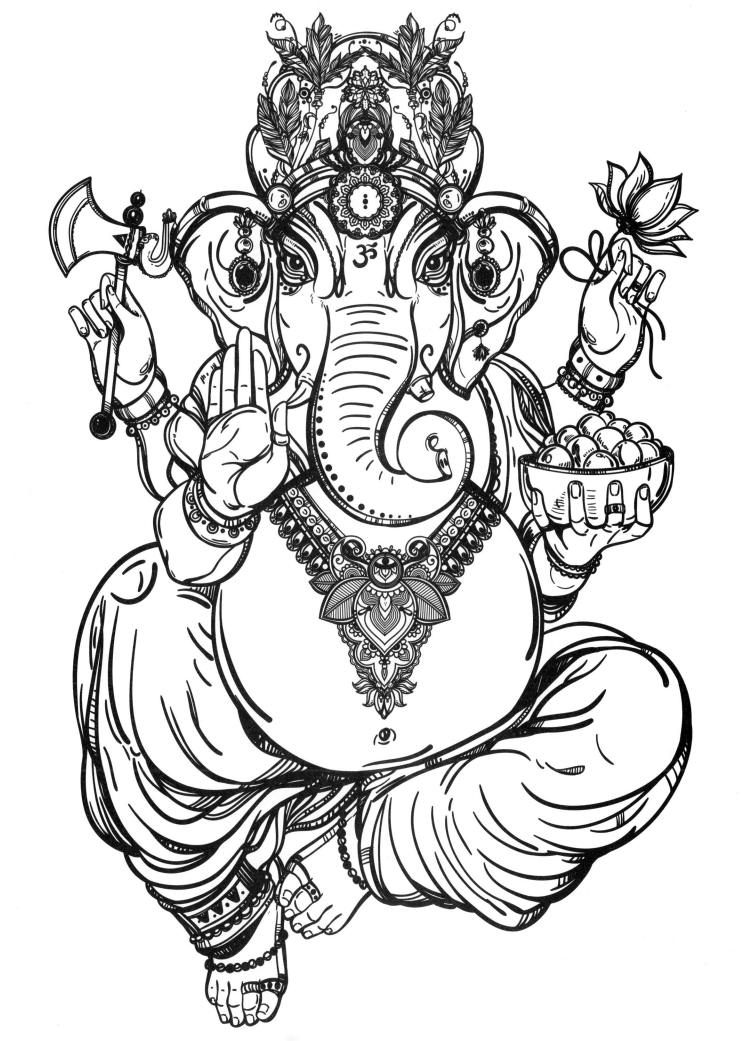

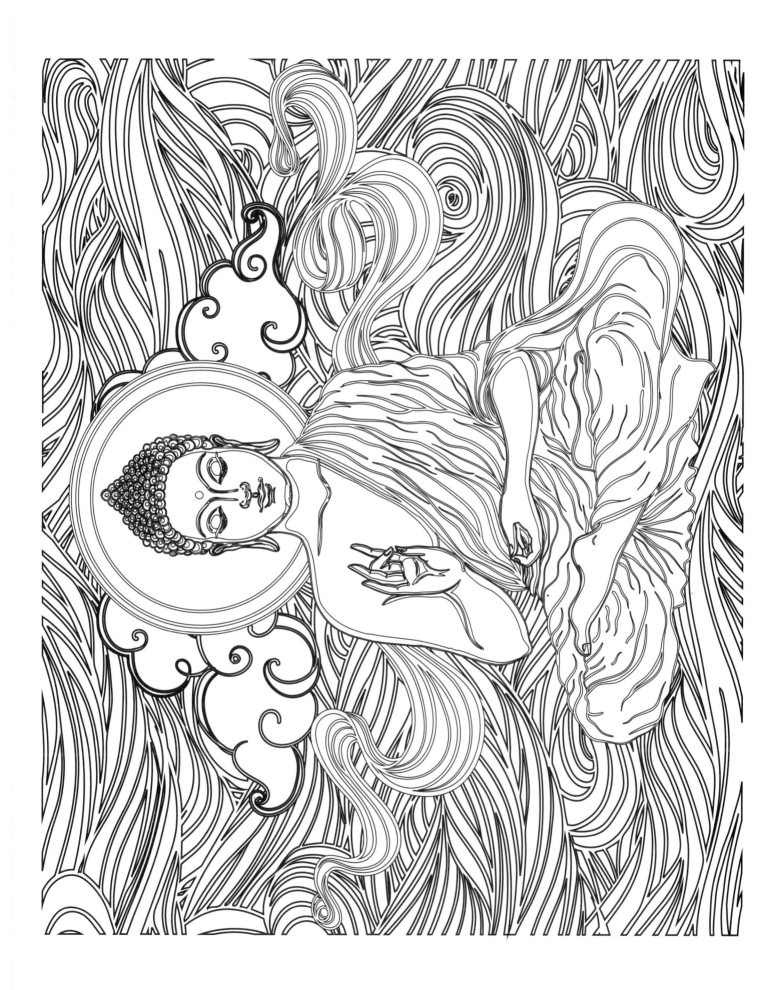

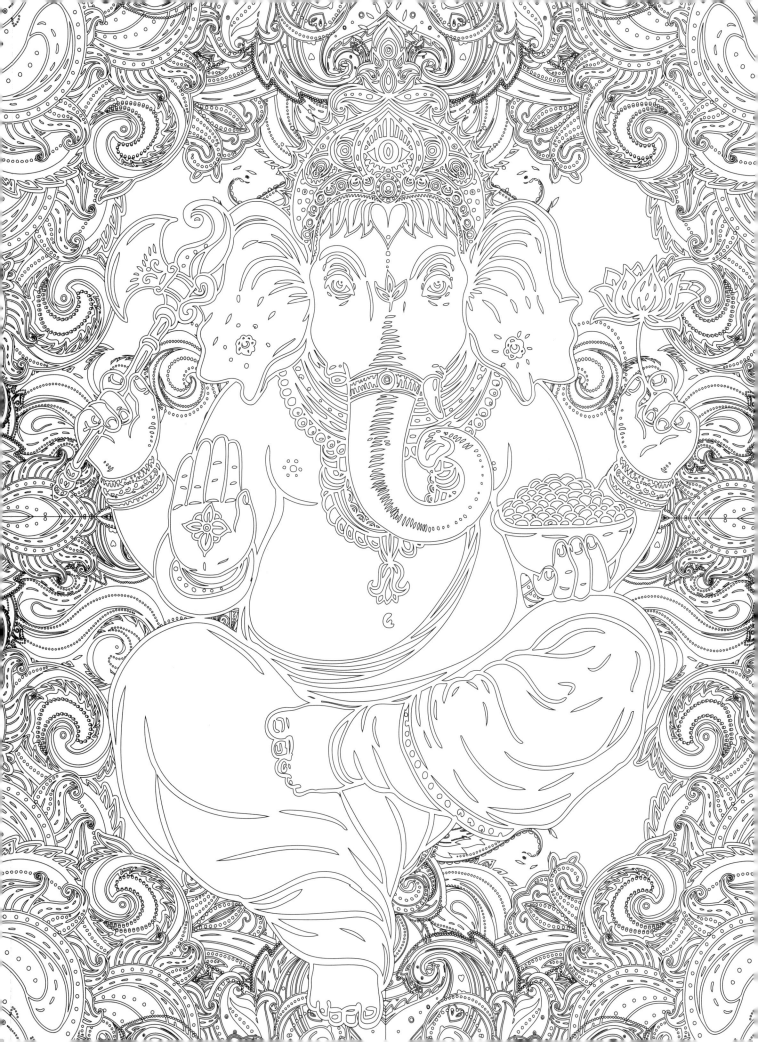

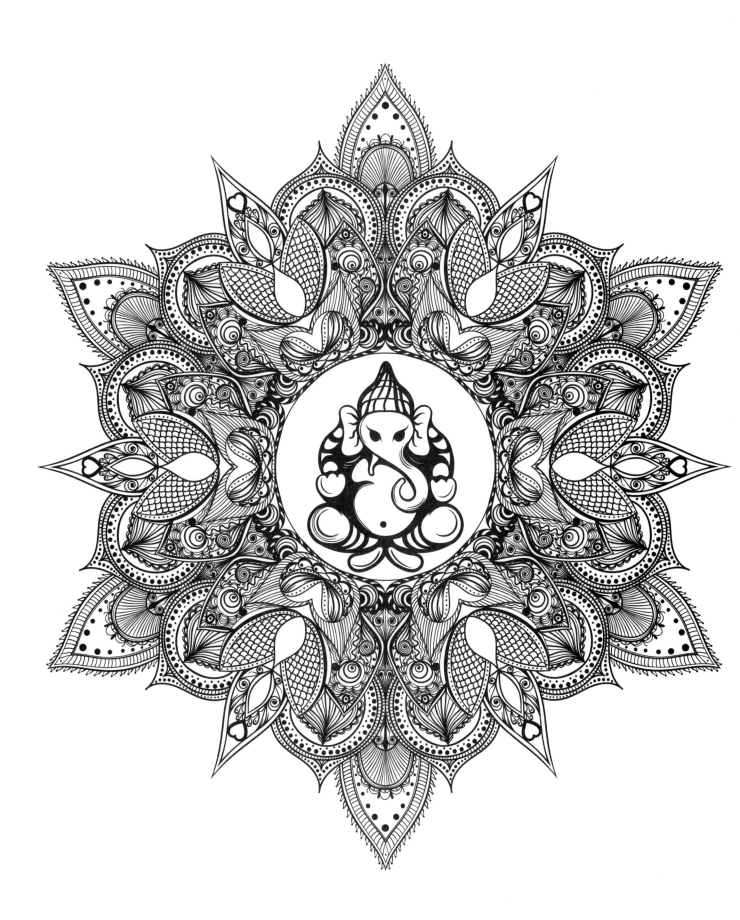

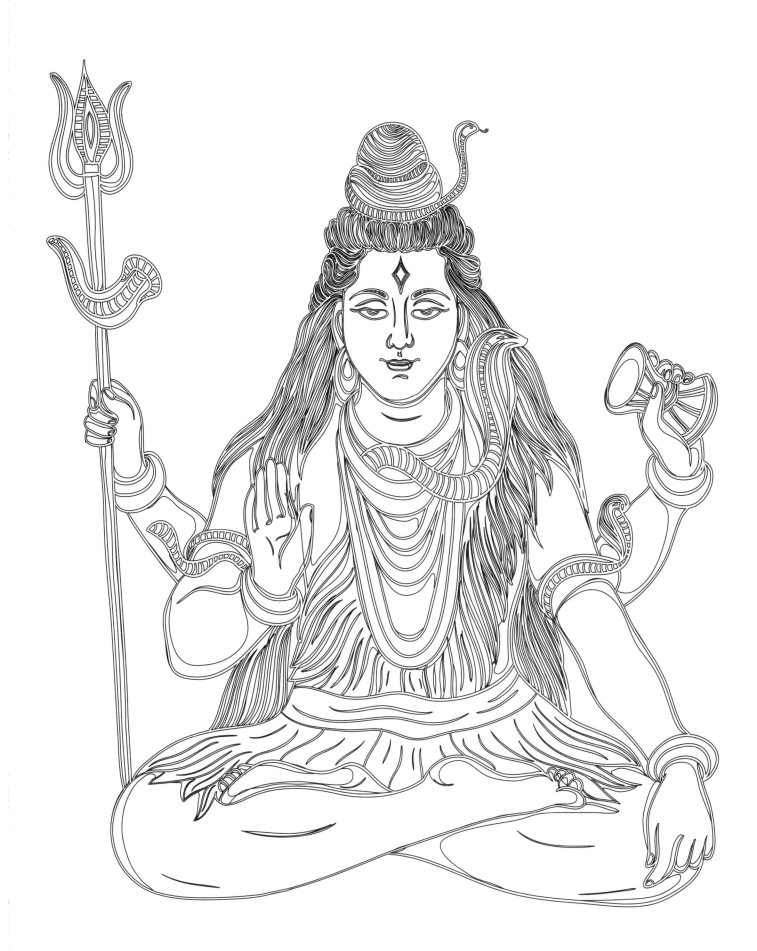

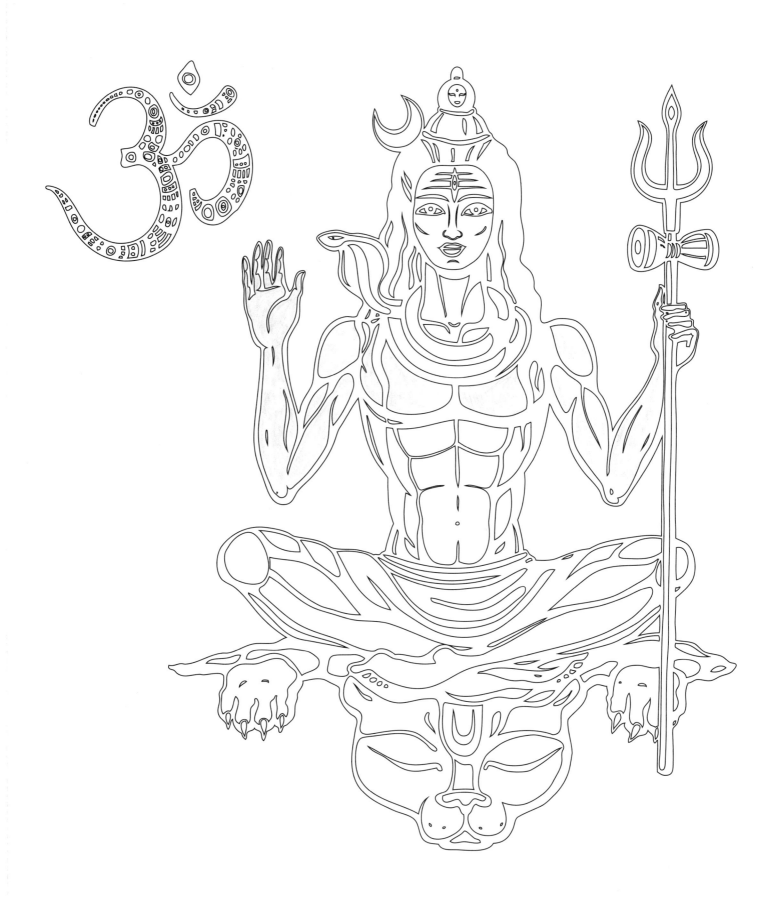

Color Bars

Use these bars to test your coloring medium and palette. Don't be afraid to try unique color combinations!

Color Bars

Color Bars

Also Available from Skyhorse Publishing

Creative Stress Relieving Adult Coloring Book Series
Art Nouveau: Coloring for Artists
Art Nouveau: Coloring for Everyone
Curious Cats and Kittens: Coloring for Artists
Curious Cats and Kittens: Coloring for Everyone
Mandalas: Coloring for Artists
Mandalas: Coloring for Everyone
Mehndi: Coloring for Artists
Mehndi: Coloring for Everyone
Nirvana: Coloring for Everyone
Paisleys: Coloring for Artists
Paisleys: Coloring for Everyone
Tapestries, Fabrics, and Quilts: Coloring for Artists
Tapestries, Fabrics, and Quilts: Coloring for Everyone
Whimsical Designs: Coloring for Artists
Whimsical Designs: Coloring for Everyone
Whimsical Woodland Creatures: Coloring for Artists
Whimsical Woodland Creatures: Coloring for Everyone
Zen Patterns and Designs: Coloring for Artists
Zen Patterns and Designs: Coloring for Everyone

The Dynamic Adult Coloring Books
Marty Noble's Sugar Skulls: Coloring for Everyone
Marty Noble's Peaceful World: Coloring for Everyone

The Peaceful Adult Coloring Book Series
Adult Coloring Book: Be Inspired
Adult Coloring Book: De-Stress
Adult Coloring Book: Keep Calm
Adult Coloring Book: Relax

Portable Coloring for Creative Adults
Calming Patterns: Portable Coloring for Creative Adults
Flying Wonders: Portable Coloring for Creative Adults
Natural Wonders: Portable Coloring for Creative Adults
Sea Life: Portable Coloring for Creative Adults